The Top 9 Asian

Destinations for family

and Co.

Everything you need to know to travel Asia on a Budget with your family and make your dream holiday become reality in 2021.

BY

The lost Traveler.

Disclaimer and Terms of Use:

Effort has been made to ensure that the information in this book is accurate and complete, however, the author and the publisher do not warrant the accuracy of the information, text and graphics contained within the book due to the rapidly changing nature of science, research, known and unknown facts and internet.

The Author and the publisher do not hold any responsibility for errors, omissions or contrary interpretation of the subject matter herein. This book

is presented solely for motivational and informational purposes only.

THE LOST TRAVELER

"Traveler for 365 Days"

The Lost
TRAVELER

For over 80 years, "The Lost Traveler" has been a trusted resource offering expert travel advice for every stage of a traveler's journey. We hire local writers who know their destinations better than anyone, allowing us to provide the best travel advice for all tastes and budgets in over 7,500 destinations around the world. Our books make it possible for every trip to be the trip of a lifetime.

Our mission is to make every country accessible for any type of wallet and family.

Our key phrase is: *"If you haven't toured the world at least once, it's as if you've never really known the place where humanity has always lived"*

TABLE OF CONTENT

Top Asian places to visit

INTRODUCTION:

Lust and wonder to visit new exotic and beautiful places is everyone's passion and will. No wonder why such new and exciting experience help you gain great and wonderful memories. Right now I would mention some of the top beautiful and magnificent places that would catch your attention and captivate you towards the beauty around us. Some of them I would discuss would be different countries with wonderful sites, including Turkey, Pakistan, India, Singapore, Nepal, Philippine, China, Japan, Indonesia, Malaysia, and Thailand. Let's see how magnificent and beautiful places are there with different food dishes and culture. Such places are the best spot for family to visit and enjoy with a small amount of cash.

1. TURKEY

Turkey is one of those countries with most fascinating and lots of beautiful places with fancy dishes. It has many sites and is very cheap to visit and enjoy such in a small amount of money. There many cities full of outstanding and iconic places such as:

1. Antalya

Antalya is a beautiful city with an abundance of things for you to see and do also it is the fifth-most crowded city in Turkey and the capital of Antalya Province. Situated on Anatolia's southwest coast lined by the Taurus Mountains, Antalya is the biggest Turkish city on the Mediterranean coast outside the Aegean district with more than 1,000,000 individuals in its metropolitan region.

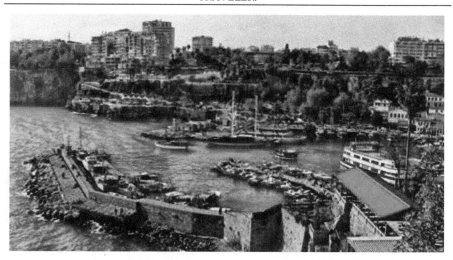

- **Lara Beach**

 Lara Beach is a flawless spot to just kick back and unwind while taking in some rays. With the Mediterranean Sea full of beautiful sites and lapping at the shore as you enjoy in the sun, it is a serene spot with bunches of traveler workplaces, so you can undoubtedly get a drink or plunk down for a feast at one of the close-by eateries.

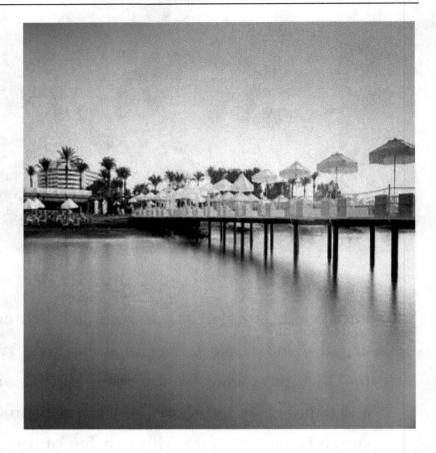

- **Hotels**

 Also in Lara beach there are five stars hotel to accommodate you and have a pleasant visit in small amount of money, such iconic titanic hotel with great view and sceneries.

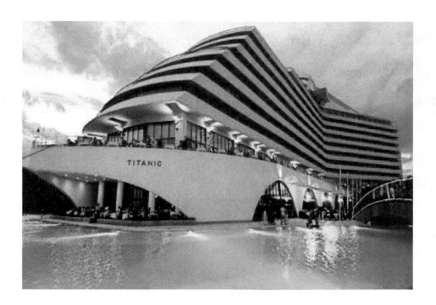

- **Kursunlu Waterfalls**
- Kursunlu is a waterfall set in the midst of a cool, pine woods. Strolling at Kursunlu Nature Park, in the midst of the extraordinary environment scented with blackberries, wild roses, and the smells of numerous different plants, may prompt an opportunity of experiencing with bunnies, squirrels, woodpeckers, turtles or other little creatures. With millions of people around the world would come.

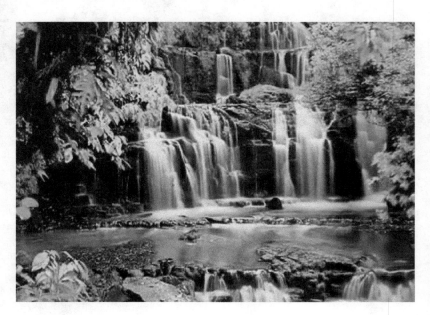

2. Istanbul

Istanbul is a significant city in Turkey that rides Europe and Asia across the Bosporus Strait. Its Old City reflects social impacts of the numerous empires that once controlled and ruled here. Also it is one of the most iconic cities for tourists and foreigners which has attracted millions of people attraction with its historic and most influential places. Like Hagia Mosque, Blue Mosque and many other places for family to visit and enjoy.

- **Hagia Mosque:**
- Hagia Sophia can be considered the best and most visited sights in Istanbul, and the adjoining Topkapi Palace. Hagia Sophia is a previous church and gallery and pronounced as one of the world's most prominent historical works and acknowledged as the world's eighth miracle. And it is the Muslim mosque now.

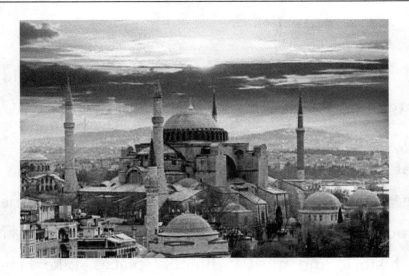

Topkapı Palace

Topkapı Palace is the subject of more vivid stories than many of the world's exhibition halls set up. Licentious kings, aggressive squires, excellent courtesans, and conspiring eunuchs lived and worked here between the fifteenth and nineteenth hundreds of years when it was the court of the Ottoman realm. A visit to the royal residence's rich structures, a gem filled Treasury, and rambling Harem gives a captivating look into their lives. Best place to visit in the country and also a great historic and iconic site for tourists.

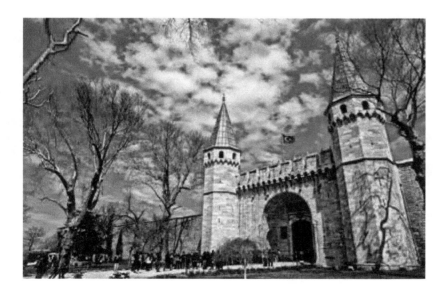

2.Ephesus

Europe's most finished traditional city, Ephesus is an antiquated site situated in Aegean Turkey. By the first century BC, Ephesus was perhaps the biggest city on the whole of the Roman Empire, bragging one the Seven Wonders of the Ancient World, the Temple of Artemis. The vestiges of Ephesus are all around saved and contained inside an enormous archeological site, making it one of Turkey's most mainstream vacation destinations.

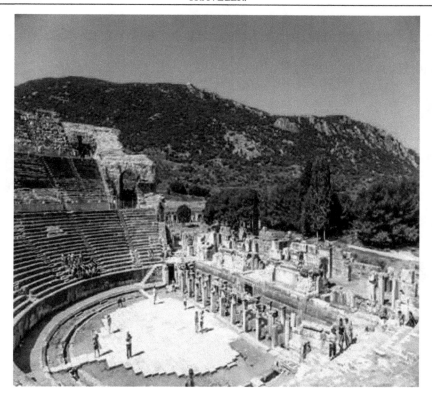

Ephesus was proclaimed a Roman settlement in 133 BC, in spite of the fact that it didn't arrive at its top until around 200 years after the fact. At a certain point, when the city was the capital of Roman Asia Minor, Ephesus housed in excess of 250,000 perpetual occupants. St.Paul lived in Ephesus, encouraging Christianity among numerous different religions. With the decrease of the harbor of Ephesus

and the terminating of the city by Germanic Goths in the third century, Ephesus started its decay.

2. PAKISTAN

Pakistan is the under developing country with so much potential and has most beautiful places and tourists points for people to visit. It is the 2nd biggest Muslim country. With so many natural beauty and wonderful sites such as:

1.Islamabad

The city is known for the remarkable and astonishing number of parks and forests, including the Margalla Hills National Park and the Shakarparian. The city is the 2nd beautiful capital in the world and home to a few milestones, with the most outstanding one being the Faisal Mosque – the biggest mosque in South Asia and the fifth-biggest planet. Best place to visit and it has places like:

2.Faisal Mosque

The Faisal Mosque is a mosque in Islamabad, Pakistan. Upon completion it was the largest mosque in the world; it is currently the fifth largest mosque in the world and the largest in South Asia. It is located on the foothills of Margalla Hills in Islamabad.

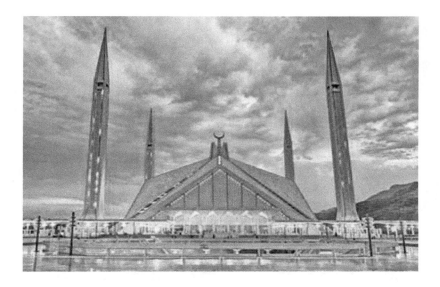

- **Shakarparian National Park**
- Shakarparian is a hill and a national and amusement park located near the Zero Point Interchange in Islamabad, Pakistan. Pakistan Monument and Pakistan Monument Museum are also located in Shakarparian.

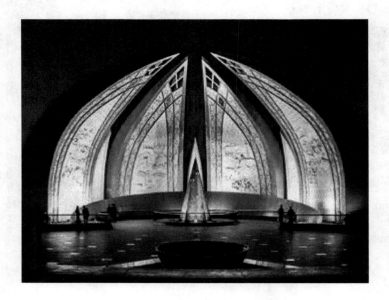

3. Kashmir

4. Kashmir is one the most beautiful and eye catching destination in Pakistan, it has most breathtaking and loving scenes. It is regarded as heaven on earth in Pakistan, because of its natural beauty and pleasant places such as Neelum valley,Banjosa lake, and Toli Pir.

- **Neelum Valley**
- Kashmir's most beautiful valley is Neelum Valley, the scenes here most captivating and heart touching, people are most hospitable and generous.

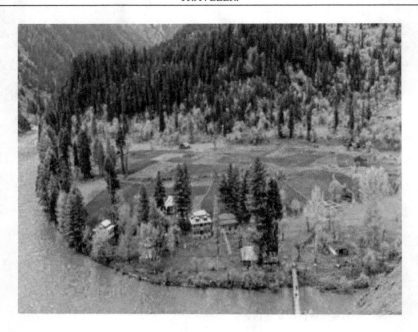

- **Toli pir**
- Toli pir is a most magnificent hilltop in Kashmir and known as popular and eye catching place for whole people around the world.

4, Swat

Swat is a district in Pakistan and is most famous for its mountains and lakes and it is considered family and tourist spot. Smack valley is a delightful valley in the Northern Part of Pakistan. It is very much associated with Islamabad the Capital City of Pakistan through the Road. Subsequent to entering in the Swat Valley you can see the Snow Clad Mountain structure the significant distance. It is an absolute necessity to visit the valley in Pakistan. Like

- **Kalam**
- kalam is situated in swat and is popular for its forest, lakes and mountains.

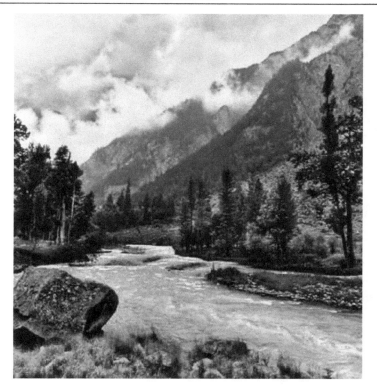

- **Mingora**
- Mingora is a city in swat district; it is the 3rd biggest in swat as it is filled with mountains and hilltops for its visitors. Best place for family and friends to visit.

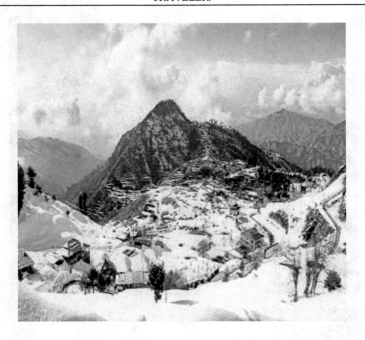

- **Mahodand Lake**

- Known for its freezing water and wealth of trout fish, the lake is situated in the Ushu Matiltan valley around 40 kilometers above Kalam. Mahodand Lake is a lake situated in the upper Usho Valley a ways off of around 35 kilometers from Kalam in Swat District of Khyber Pakhtunkhwa region of Pakistan.

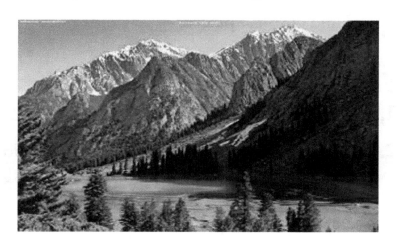

1. CHINA

China is one of the biggest countries in the world not only populated but it is teemed with most exotic places as well let's take look at these for families and friends to visit. And also it is full with so many historical and cultural places.

1. Huairo

2. It is a district in china with one of the wonders around the world such as Great Wall of China.

- **Great wall of china**
- The Great Wall of China is a progression of fortresses that were worked across the borders northern lines of old Chinese states and Imperial China as assurance of safety against different roaming groups from the Eurasian Steppe.

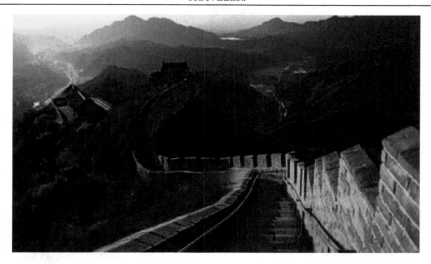

2.Beijing

Beijing, China's rambling capital, has history extending back 3 centuries. However it's referred to as much for present day architecture as its old destinations, for example, the stupendous Forbidden City intricate, the magnificent royal residence during the Ming and Qing lines.

- **The Forbidden City and the Imperial Palace**
- The Palace Museum is a public historical center housed in the Forbidden City at the center of Beijing. It was set up in 1925 after the last

Emperor of China was ousted from his castle and made its way for people in general.

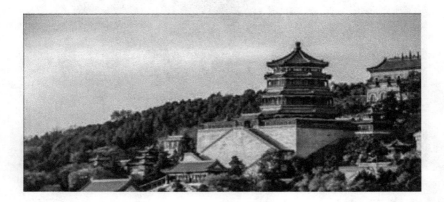

2.Sichuan

Sichuan is a great province in a china which is known for outstanding and marvelous architecture such as Leshan Giant Bhudda.

- **Leshan Giant Bhudda**
- Various little Buddhas were cut around this immense sculpture. Individuals even unearthed the bluff burial places of the Han Dynasty around the Leshan Giant Buddha. Different noteworthy locales make the Leshan Giant Buddha especially significant for archeologists and exploring individuals' ways of life in old occasions.

This stone sculpture cut during the Tang Dynasty stands 71 meters high at the meeting purpose of the Minjiang, Dadu, and Qingyi streams. Explorers can see the Leshan Buddha during a waterway visit, where boats drift down the creek and pass the figure, or during a climbing endeavor, where gatherings give along with the bluff's highest point just as scale the feet of the Buddha. The Leshan is the most significant stone Buddha design on the planet and has been recorded as a UNESCO world legacy site since 1996; don't miss it!

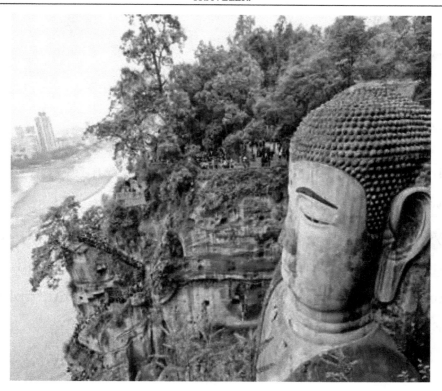

2. India

India is the second most populous country in the world with great amazing places to visit and spent your time there, while this country is full of great heritage and perfect places in the world. Hospitality and love is part of their tradition and multiple religions are common here.

1.Amritsar

Amritsar is the biggest and most significant city in Punjab and is a significant business, social, and transportation focus. Likewise, it is the focal point of Sikhism and the site of the Sikhs' chief spot of love — the Harmandir Sahib, or Golden Temple.

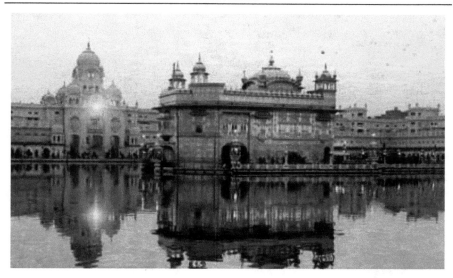

Historical otherwise called Rāmdāspur and conversationally as Ambarsar, is the second most crowded city in the Indian territory of Punjab. The city is the authoritative base camp of the Amritsar region and is situated in the Majha area of Punjab.

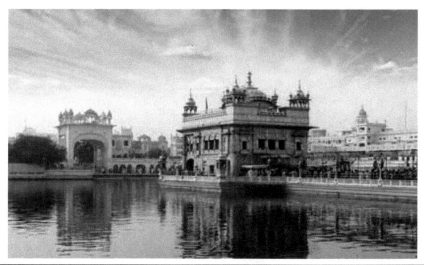

• Ladakh

Ladakh is generally acclaimed for stunning scenes, the clear skies, the most elevated mountain passes, exciting experience exercises, Buddhist Monasteries, and celebrations.

- **Goa Beach**

- Goa is likewise known for its sea shores, and is most loveable place to enjoy with your family and friends. Most popular places known for beaches is only Goa Beach.

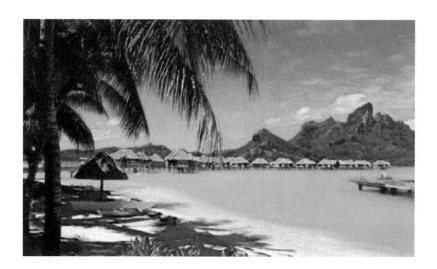

- **The Dudhsagar Waterfalls**

- The Dudhsagar Waterfalls are arranged on the Goa-Karnataka line and are one of India's must-see sights. The four-layered cascade structure is one of the tallest in India and is situated on the Mandovi River. The white waterfalls from a tallness of almost 1017 feet off a nearly steep mountain face. They structure a piece of the Bhagwan Mahaveer Sanctuary and Mollem National Park, so the ideal approach to contact them is by entering the public park and taking a van distributed by the recreation center to the falls.

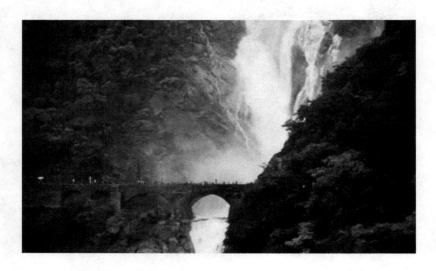

The Dudhsagar journey inside the recreation center is shut to general society; however, you can arrive at the cascades by traveling from Kulem and following the jeep trail. Another conceivable course is the trip from Castle Rock in Karnataka. Coming at the waterfalls won't be a simple errand; however, it merits each ounce of exertion put into it. They are best capable during the storms as they lose their power during the dry season.

- **Agra**

Agra is quite possibly the most-visited urban community in India when the Mughal Empire's capital, Agra, is presently home to the impressive design known as the Taj Mahal.

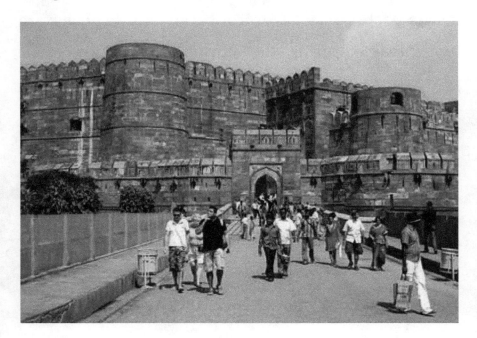

- **Taj Mahal**
- While spectacularly delightful, the Taj Majal can be extremely packed. Likewise worth finding in Agra is the Agra Fort, which is very much like the Red Fort of Delhi. You can visit this sixteenth century fortress and even investigate the inside of its wonderful royal residence.

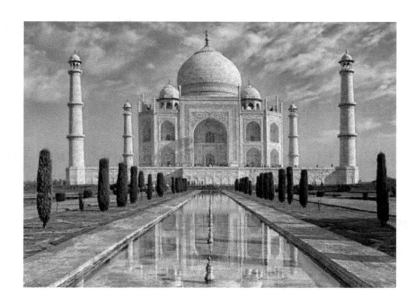

3. Nepal

Nepal, a landlocked country among India and China, is known for its mountain tops. The little nation contains eight of the ten most elevated tops on the planet, including Mount Everest and Kanchenjunga – the world's tallest and third tallest separately.

1.Khumbu Valley

Celebrated for its breathtaking mountain tops and the devotion and hospitality of its residents (the Sherpas), the Everest district (Khumbu) is quite possibly the most mainstream objections for vacationers in Nepal.

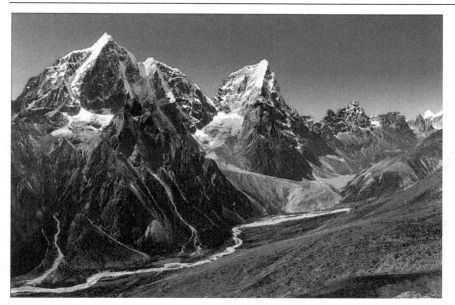

- **Gokyo Valley**
- Perhaps the most beautiful valleys in Nepal, the Gokyo valley, lies towards the west of the more popular Khumbu locale of the Himalaya. The peaceful valley flaunts broad fields for yaks to munch during summer, and the flawless turquoise lakes are just amazing. Gokyo can be visited after journeying up to Everest Base Camp by adding five days to the schedule.

On the off chance that Gokyo is your principal objective, at that point, the journey goes up the

Everest trail just to the extent the teahouses at Kenjoma (where the path from Khumjung joins the absolute path). The way leads up towards Mong La pass before dropping steeply down to the Dudh Koshi River banks. The trail at that point goes past rhododendron and oak timberlands and cascades, which are regularly frozen. Two or three hours on this captivating path, and you show up in Dole, whereyou go through the night in a teahouse.

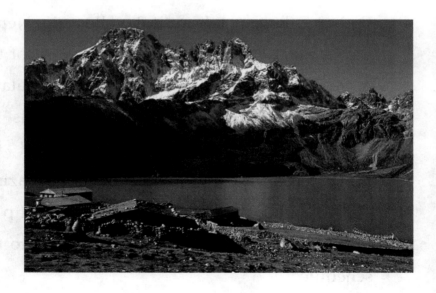

1.Kathmandu

Kathmandu is especially renowned for its religious landmarks. Different sanctuaries, temples, cloisters, monasteries, and stupas embellish the city's scene, especially the Pashupatinath Temple and the Changu Narayan, which are well known for their shocking, complex strict works of art.

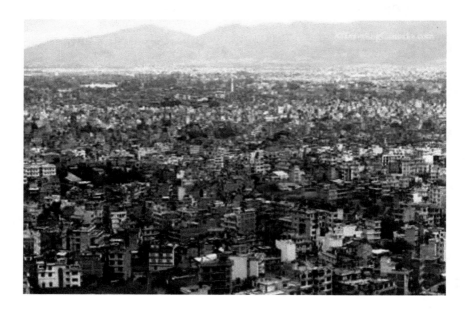

- **Pashupatinath temple**
- Pashupatinath temple is a sacred and most significant religious destinations in Asia for lovers of Shiva. Inherent in the fifth century and later redesigned by Malla rulers, the actual site is said to have a unique history and existed from the earliest starting point of the thousand years when a Shiva lingam was found.

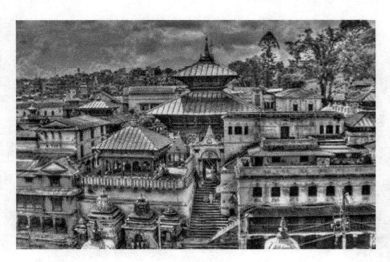

3. Bhaktapur

Bhaktapur has the best-safeguarded castle yards and old downtown area in Nepal and is recorded as a World Heritage Site by UNESCO for its rich culture, sanctuaries, wood, metal, and stone works of art. It stays the best safeguarded of the three, regardless of the harm of the 2015 earthquake. It stays the best saved of the three, in spite of the harm of the 2015 tremor.

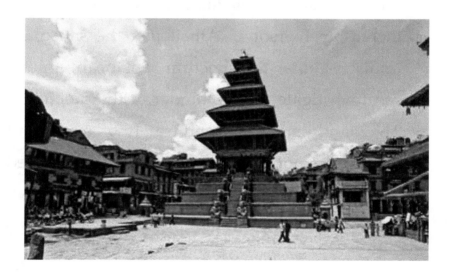

- **Nyatapola Temple**

Nyatapola Temple is an eighteenth century sanctuary situated in Bhaktapur, Nepal. It is the tallest structure in the valley and the tallest sanctuary in the country. The sanctuary was implicit 1702 and is devoted to Goddess Siddhi Lakshmi, a manifestation of Goddess Parvati. The icon of the Goddess, which is introduced in the sanctum sanctorum, is accepted to be incredibly fearsome. Albeit just the sanctuary ministers enter the sanctum sanctorum, guests can investigate the remainder of the sanctuary. The landmark has endure two significant seismic tremors in the area and has endured minor harms. It is additionally, hence, known for its underlying strength.

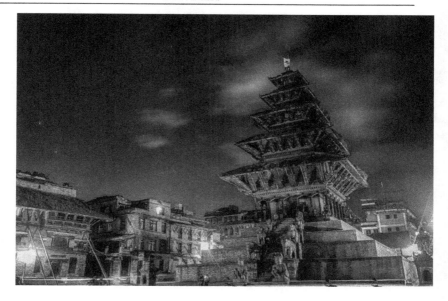

4. Singapore

Being overly perfect, Singapore as a perfect city, it is famous for having probably the cleanest roads on the planet, generally because of a 50,000-in number cleaning labor force utilized to keep the streets clean.

1.Gardens by the bay

Gardens by the Bay are a tremendous, bright, advanced park in the territory of Singapore. Among the highlights are the acclaimed Super tree structures. These offer a great skywalk over the garden, with curiously large shell formed nurseries that reproduce Perfect Mountain like shapes, which are quite attractive for the tourists.

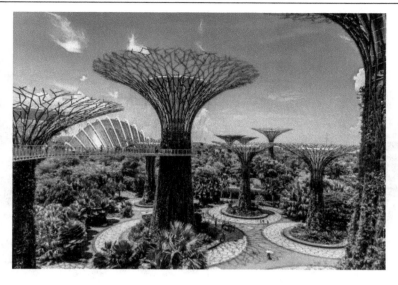

A hint of God's creation is found only contiguous the Marina Reservoir. This park with 101 hectares of the land zone is a recovered land in focal Singapore. This is Gardens by the Bay, a grand desert spring abounding with displays and pleasures. You can discover relaxation and sporting exercises, instructive projects, and visits to these nurseries. Also, a visit here allows you to connect with nature.

There are many attractions in the Gardens by the Bay; all you require is to pick which one will suit your taste. This is likewise extraordinary for family holding, the date for two, and an association among your circles.

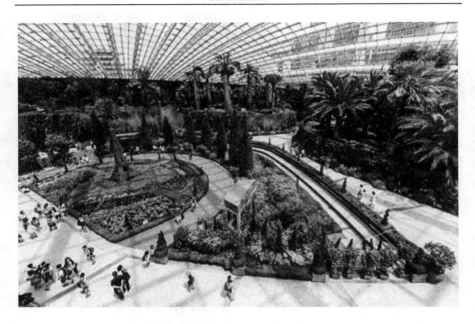

1. Singapore flyer

2. Considered as the world's most giant perception wheel, the Singapore Flyer took over two years to assemble following its essential function in September 2005. It stands 165-meter-tall and is one of the best tourist spots, especially for family and friends, but it is also the most beautiful piece of work.

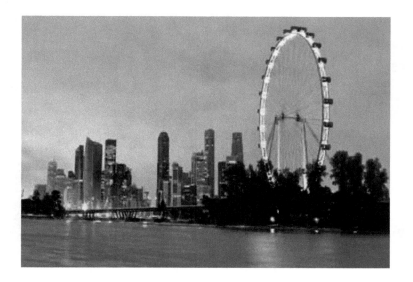

Singapore Flyer is a goliath Ferris Wheel. In the event that statures thrill you, at that point this is a ride that you would thoroughly appreciate. It is one of the tallest Ferris wheels on the planet today.

The perspectives from high up are amazing, and one can get a brief look at Singapore in a solitary go. Appreciate this exciting experience on your excursion to Singapore, and after the ride investigate some close by places in Singapore as well. Peruse on, to understand what everything is accessible close by to do in Singapore.

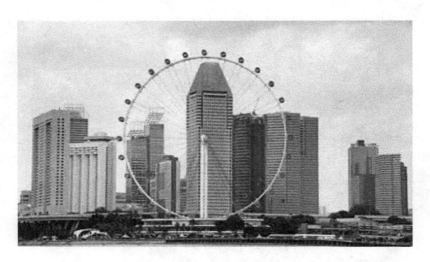

2. Pulau Ubin

While Pulau Ubin is a historical and ancient place where some granite stones are accepted to be over 200 years of age, granite quarries gave the underlying attraction to early neighborhood settlement, and a significant part of the granite was utilized for Singapore's initial turns of events. A heaven for nature sweethearts, Pulau Ubin, has a lot to bring to the table with its rich greenery and bountiful untamed life. Visit the unwanted quarries and become familiar with their local plants as you wander around the island.

- **Chek jawa**

The Chek Jawa wetlands are one of the fundamental attractions of Pulau Ubin and home to a flourishing biological ecological system of the country's biggest assortment of natural life. To get to Chek Jawa, you need to stop your bike and walk since the footpaths are delicate and tight. The wetlands generally comprise of mangroves, rough shores and a sandy shore. During low tide, hope to see the little marine animals like mudskippers, crabs and more modest fish. For a more extravagant comprehension of the natural life in Check Jawa, join a guided strolling visit and gain from the specialists.

5. Philippines

The Philippines is a modest travel destination, even by Southeast Asian principles. A few inns might be more costly than you would expect; however, all in all, it is a truly moderate travel objective.

1.Ifugao

Ifugao, a place for wet-rice agriculturalists possessing northern Luzon's hilly territory, Philippines has made the places with beautiful outlooks. Their incredible arrangement of watered rice porches steeply formed, mountain-terraced dividers of stone that lean marginally internal at the top is widely acclaimed and was created with an essential innovation.

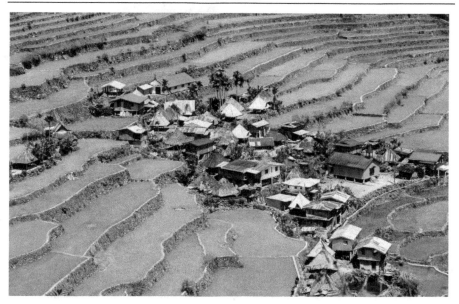

- **Banaue**
- Banaue, the arrangement of flooded rice porches in the mountains of north-focal Luzon, Philippines, made over 2,000 years prior by the Ifugao public, now it is the most beautiful and exotic place for the family to visit. Also situated in a few towns, they are aggregately known as the Banaue rice.

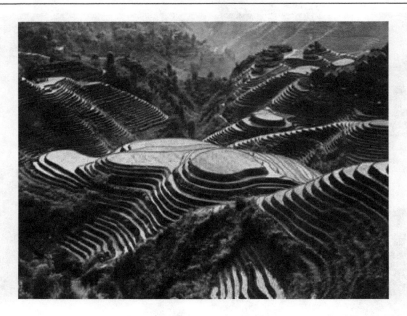

1. Palawan

2. Palawan Island Philippines is renowned for white beaches, clear water and astonishing biodiversity, additionally for Puerto Princesa Underground River. Palawan is the first run through on the platform. Best place for families to visit and enjoy.

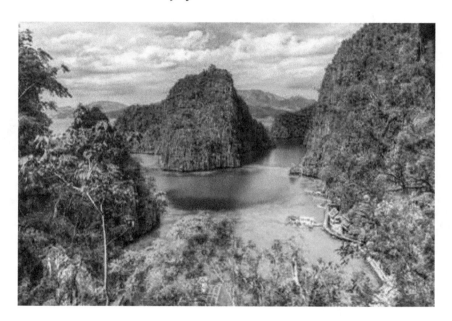

- **Coron Island**
- Coron is a tropical island in the territory of Palawan in the Philippines. Coron is most famous for a-list World War II-time wreck. The island likewise offers limestone karst scenes, lovely beaches, perfectly clear freshwater lakes, and shallow-water coral reefs.

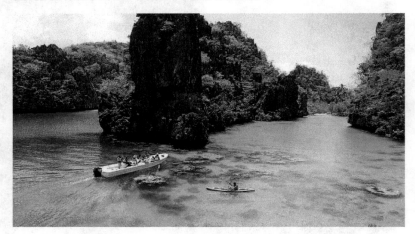

• Puerto Princesa

This underground waterway framework's feature is that it streams straightforwardly into the ocean, with its saline lower half exposed to flowing impact. The waterway's sinkhole presents striking, eye-catching rock arrangements.

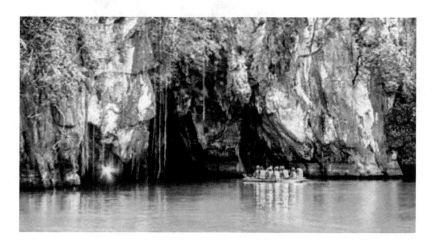

2.Mountain province

Mountain province is one of the most fascinating and beautiful province in Philipines and it is known for its beautiful and wonderful places for tourist to visit.

- **Sagada**
- Sagada is known for its grand mountain valleys, rice fields, reviving waterfall, limestone caverns, and ocean of mists.

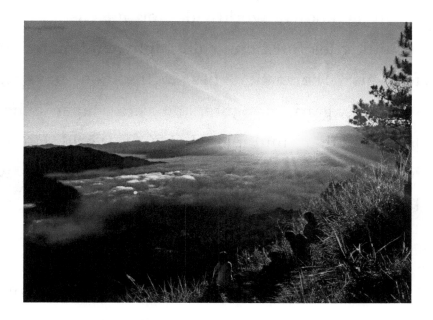

6. Japan

Japan is known worldwide for its customs, arts, including tea functions, calligraphy, and many other festivals. The nation has a tradition of special nurseries, gardens, figure, and verse. Japan is home to more than multiple UNESCO World Heritage locales and is the origin of sushi, generally well known.

1. Naoshima

2. Well surrounded adequately by the Seto Inland Sea's shimmering waters, the unspoiled island of Naoshima lies between the beautiful Japanese islands of Honshu and Shikoku. Its dazzling view, extraordinary contemporary craftsmanship, historical centers, and various outside models are an exceptionally famous traveler and tourist spot and destination.

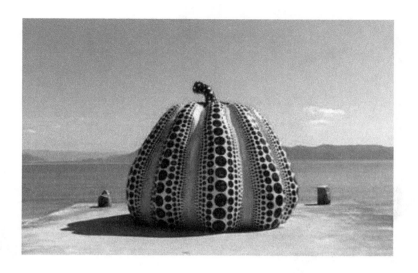

Naoshima Island, otherwise called Japan's Art Island, is acclaimed for its craft galleries and outside models.

Most popular is the "giant pumpkin" by craftsman Yayoi Kusama, the informal symbol for Naoshima. As far as I might be concerned, visiting Naoshima got going as an insane pumpkin chasing mission; however, it transformed into an out-and-out relationship. To help other people visiting, I've assembled a guide of activities in Naoshima.

3. Shirakawa-go & Gokayama

4. Celebrated for their breathtaking settings and traditionally covered rooftop farmhouses, they consider as a real part of focal Honshu's most famous vacation spots.

While this implies they can become very busy, especially during Golden Week and the cherry bloom season, the towns genuinely are a treat to visit. This is because the unmistakable gassho-zukuri structures that look so dazzling encompassed by prolific farmland and eminent nature loan them an enchanting, serene, and provincial feel.

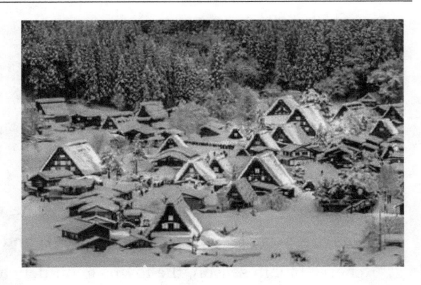

Shirakawa-go is a famous for its familiar scene and covered rooftop homes. This article presents must-see spots, nearby dishes and road food, and headings to this touring objective.

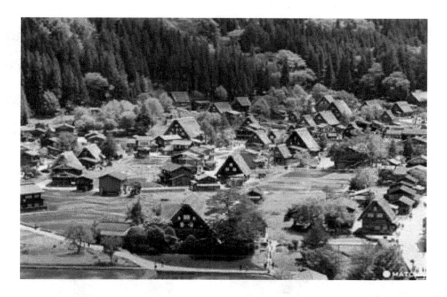

5. Nikko

6. Nikko is situated in the northwestern of Tochigi Prefecture, most famous for its vast and rich nature, just as the numerous celebrated touring spots, including original altars and sanctuaries. As it used to be the hallowed place and sacred where there is mountain love, innumerable individuals visit the site for its unmistakable otherworldly climate.

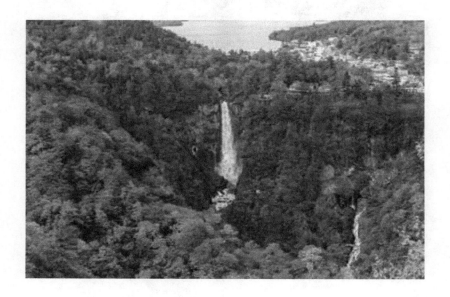

The Shinkyo connect resembles the access to Nikko's sanctuaries and sanctums mind-boggling, the ideal spot to begin your excursion from. The

actual scaffold is important for the Futarasan Shrine, one of the trees in Nikko that love Mount Futara as a "shintai". In the Shinto religion, a shintai is an item wherein a heavenly nature can live, giving an actual structure available to its devotees.

A legend says that when Saint Shodo showed up here, the water straeam was so solid he was unable to cross the waterway. A divine being encouraged him by sending two snakes that transformed into an extension.

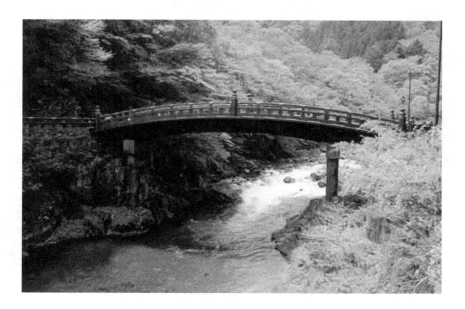

4.Tokyo

Tokyo's cultural side is well known for its various activities and top attractions, including historical centers, celebrations, universally noted cooking, and elite athletics clubs, including baseball, football, and customary Japanese pursuits like sumo wrestling.

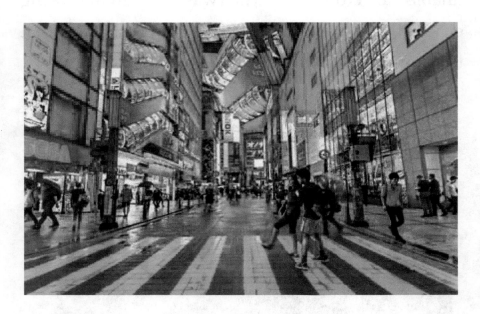

Tokyo, opposite the Ariake Coliseum, one of the scenes for the impending Tokyo 2020 Olympic Games, involves 8,000 square meters of a four-story expanding on the edges of the city. The amusement

park comprises of six regions dependent on various topics, with entire areas committed to Sailor Moon and Evangelion. The scenes are a mashup of the real world and fiction: Space Center presentation portrays the dispatch of a Saturn V space transport from the 1970s, while the Global Village includes shockingly precise entertainments of five urban communities in Asia and Europe with fantastical augmentations like mythical serpents and robots tossed in for no particular reason.

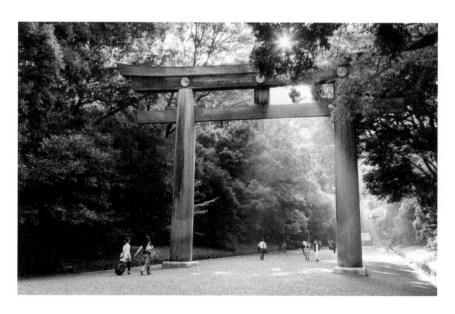

7. Indonesia

Indonesia is among the region known for the fire region, an area with probably the most dynamic volcanoes on the planet. A significant number of the nation's volcanoes, for example, Mount Merapi, are famous for their vicious emissions, and they're shocking, however most popular one now.

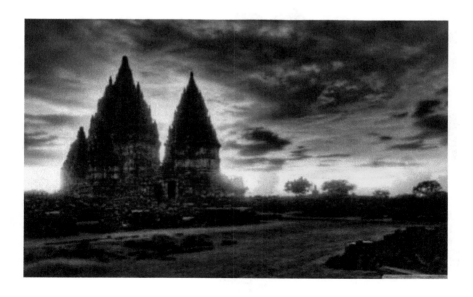

Mount Bromo

Mount Bromo is likely quite possibly the most renowned grand attraction in East Java of Indonesia. It is well known for its superb dawn view and view on the spring of gushing lava cavity there, which is uncommon to see.

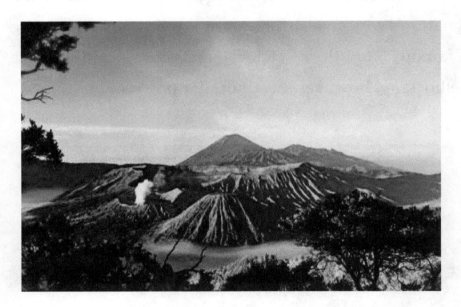

The city is prestigious, just like the focal point of Javanese expressive arts and culture, for example, the Wayang Kulit shadow puppetry, just as for music, artful dance, show, verse, and batik. Home to many captivating attractions and two UNESCO Heritage Sites, Yogyakarta is something beyond a social and strict site.

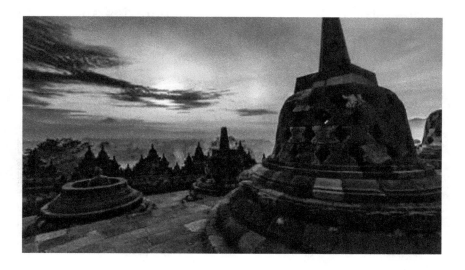

Yogyakarta is one of the most enjoyable cities in Southeast Asia, in spite of the fact that you might never have heard of it before now. Make sure to take day trips from Yogyakarta to Borobudur or Prambanan (or both, if possible!) to round out your Yogyakarta itinerary.

2. Ubud

Known as Bali's craft and culture capital, Ubud is a definitive spot to appreciate different customary exhibitions, from the infamous Kecak fire dance to nearby adolescents rehearsing their gamelan in the city center. You can get one of these exhibitions anyplace from the Royal Palace to eateries and public spots.

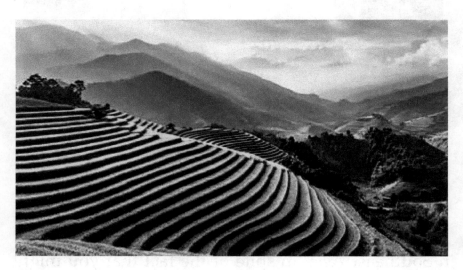

The Ubud Monkey Forest, situated on focal Ubud's edges, is home to more than 700 since quite a while ago followed macaques. This regular safe-haven is maybe the most popular in Bali because of its local area based administration, area, and simple entry.

Administered by the Padangtegal town, Ubud Monkey Forest is a logical exploration position and a site of profound and social perspectives, as neighborhood residents purify consecrated sanctuaries. The Ubud Monkey Forest is also called the Sacred Monkey Forest of Padangtegal, and, by its authority assignment, Mandala Wisata Wenara Wana.

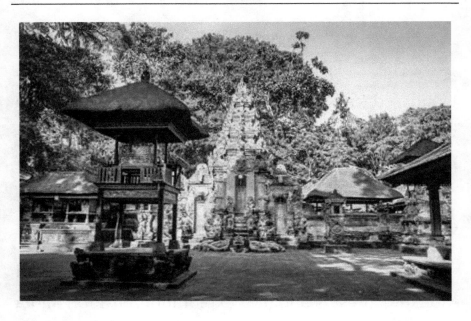

1. Derawan Island

2. This archipelago in East Kalimantan is probably the best of tropical heaven, involved six unique islands and some more modest islets, each with its own experiences and appeal. Maratua Island, for instance, is known for its heavenly ocean caverns, lakes, and sumptuous hotels. Kakaban Island offers swimming in a lake loaded with stingless jellyfish. Sangalaki Island is well known for jumping and swimming because of its flourishing underwater scene, loaded up with coral, manta beams, turtles, and that's just the beginning. The generally far off area helps save this archipelago's common magnificence, making it unblemished and wonderful island heaven in Indonesia.

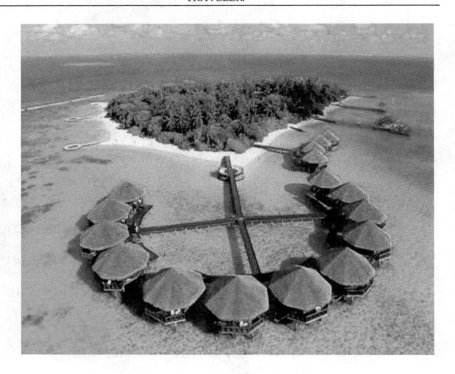

3. Wae Rebo

This small and isolated village was recognized for its rebuilding of the traditional Mbaru Niang traditional house based on the spirit of community cooperation towards a sustainable tradition, while at the same time improving its village welfare. Wae Rebo is a small, very out of the way village.

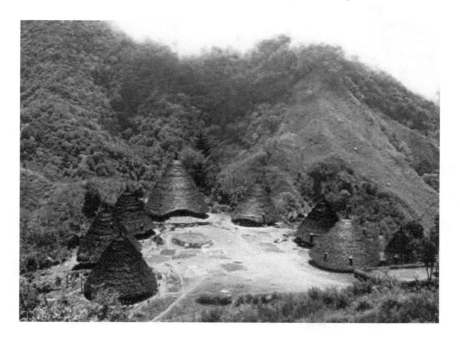

- **LINGKO SPIDER WEB RICE FIELDS - WALKING TOURS**
- The most stunning perspective over some of these fields is offered at Cara Village arranged on a little slope 17km west of Ruteng in Cancar. With their round, spider trap structure, these parcels are remarkable eye-catchers in Manggarai.

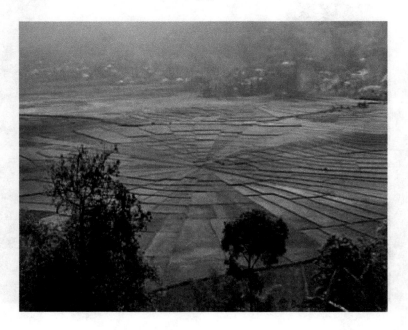

8. Malaysia

There are a lot of great nations on the planet. It is because that Malaysia is uncommon among great countries on the earth. Malaysia is unique on account of the variety of races, religions, and societies. Because of the variety, Malaysian produces a remarkable component that different nations don't have. Malaysia is known for its lovely seashores, separated islands, raised slope stations, and UNESCO World Heritage Sites.

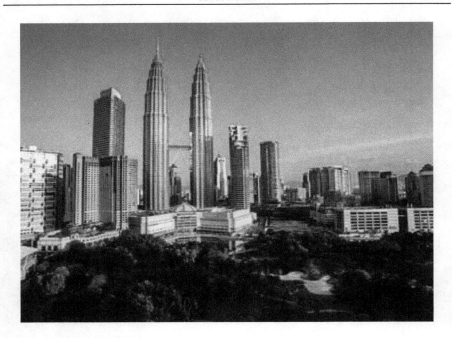

1. Selangor

Selangor portrays Malaysia's generally evolved and populated state that paves the way to Kuala Lumpur's never-ending suburbia.

Selangor is occupied with so much amazing and interesting things; shopping centers spread in numerous ways. At the point when you can't shop in any way, shape, or form shop any longer, head to the close by Genting Highlands — Malaysia's variant of Vegas roosted on top of a mountain. The First World Hotel and Plaza is the world's most prominent inn with 10,500 rooms and an amusement park.

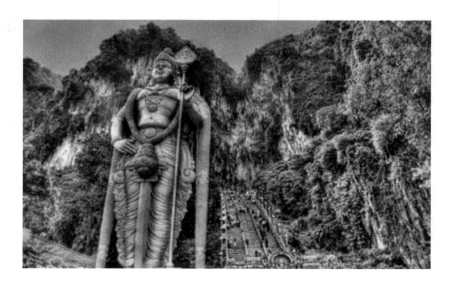

- **Malaysia Agriculture Park, Shah Alam**
- This 1,258ha park is the biggest agroforestry park on the planet, containing tests of practically every rural asset in the country, including oil and coconut palms, padi fields, organic product trees, and elastic trees all set in a rainforest. Through various outside displays, live showings, nature trails, and a large group of instructive projects, guests are offered unmatched freedoms to find out about and make the most of Malaysia's rich characteristic ascribes. Different attractions here incorporate two dams, a fishing lake, a mild house, an engineered overpass, and a winged creature and safari park. Bikes are accessible available inside the recreation center. Spending chalets are likewise accessible.

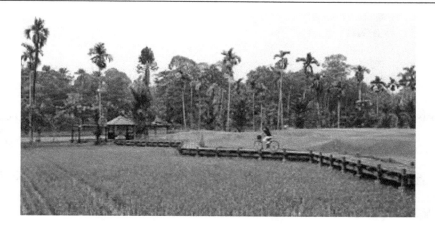

1. Tanah Rata

The little town of Tanah Rata is the standard base for spending voyagers wishing to investigate Malaysia's delightful Cameron Highlands. With temperatures that plunge as low as 50 F around evening time, Tanah Rata is an invited break from Southeast Asia's warmth and stickiness.

Straightforward, green tea estates sticking to the encompassing slopes and never-ending blossoming blossoms loan a sweet smell to the air. The peacefulness of the landscape is infectious; Tanah Rata's vibe is charmingly loose, and individuals are benevolent. Wilderness strolls anticipate the daring while strawberry ranches and rich nurseries engage those wishing to remain nearer to progress.

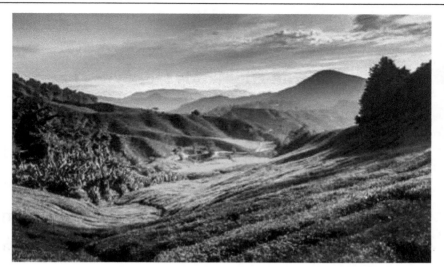

Cameron Highlands Discover The History

In the event that you are around Cameron and need to find out about its set of experiences, at that point visit the Cameron Highlands Discover The History that includes a portion of the important photos and antiquities with respect to Cameron. The shows are worked by the retreat that houses the display space. You can remain there to have an intensive admittance to the antique highlights that are captivating and will make you nostalgic about the bygone eras. There are loads of highlights that will cause you to think back on your adolescence. The best feature of the display is the Time Tunnel through which you can investigate the historical backdrop of Cameron. The displays are interesting to individuals of all age gatherings and you can visit here with your family just as companions.

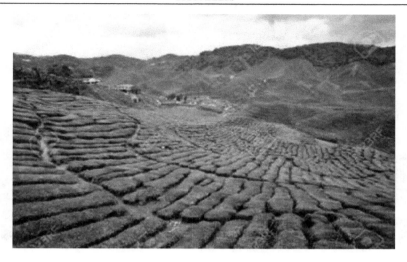

1.Kuala Lumpur

KL is broadly perceived for various milestones, including Petronas Twin Towers (the world's tallest twin high rises), Petaling Street swap meet, and Batu Caves, which is more than 400 million years ago. Kuala Lumpur is the capital city of Malaysia, flaunting shining high rises, provincial design, enchanting local people, and a horde of characteristic attractions. Separated into various areas, its principle center is known as the Golden Triangle which contains Bukit Bintang, KLCC and Chinatown.

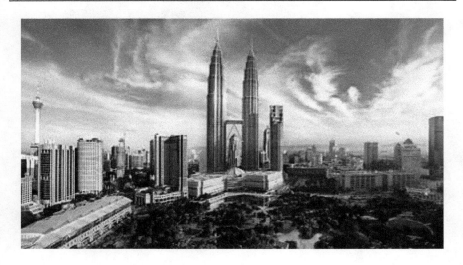

- **Menara KL Tower**
- Remaining on the Bukit Nanas Forest Reserve, the 421m-high KL Tower is now the world's fifth tallest design. Authoritatively known as Menara KL, it has been eclipsed by the Petronas Twin Towers however stays a significant structural marker and flaunts excellent perspectives on the city. The survey deck is in any event 100 meters higher than the Petronas Tower's Skybridge - to get free tickets make sure to show up before the expected time.

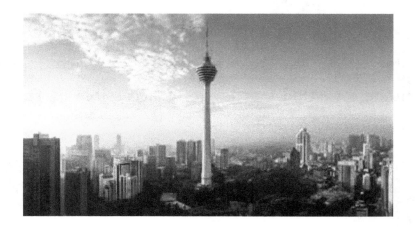

1. Taman Negara

In a real sense, Taman Negara signifies "public park" in Malaysia, and well, that is the thing that it is! Taman Negara is Malaysia's most established public park and is viewed as one of the world's most established tropical rainforests. A long shade walkway allows guests to see life high in the trees that regularly isn't obvious starting from the earliest stage.

You can appreciate cascades and wonderful journeying, fowl spots, boating, fishing, night safaris, and there's even an opportunity to see wild elephants — in case you're lucky. Vacationers rest across the waterway in Kuala Tahan and afterward take modest boats to the recreation center passage. Some genuinely guided journeying is accessible in Taman Negara, as is surrendering.

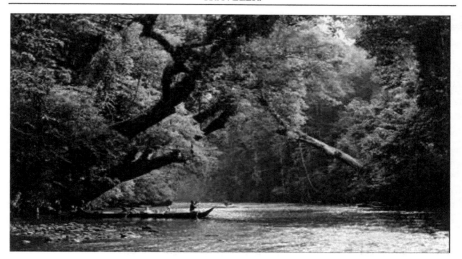

11. Thailand

Situated in southern Asia it is known for extraordinary food, hand to hand fighting, sea shores, and numerous sanctuaries. Thailand likewise has numerous islands that are notable that have various retreats for sightseers. On the off chance that you have ever eaten Thai food, you'll know it's a remunerating experience.

Thailand is home to natural life in its numerous public parks, seashores, and rocky territory. In the south, there are whole sea shores loaded up with monkeys, with travelers rushing to places like Monkey Beach on Koh Phi to perceive beauty.

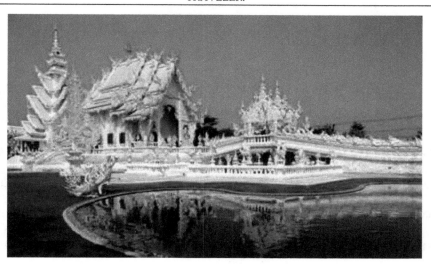

1. Bangkok

generally acclaimed for its loved nightlife scene and cheerful climate, this is the place where 99%, everything being equal, will end up at any rate once when in Bangkok. It is additionally a convenience focal point for some as an incredible assortment of modest convenience types can be found inside the region of Khao San Road. Bangkok, Thailand's capital is an enormous city known for its resplendent hallowed places and energetic road life. The boat-filled Chao Phraya River takes care of its channels, streaming past the Rattanakosin imperial area, home to extravagant Grand Palace and its sacrosanct Wat Phra Kaew Temple. Close by is Wat Pho Temple with a huge leaning back Buddha and, on the contrary shore, Wat Arun Temple with its lofty advances and Khmer-style tower.

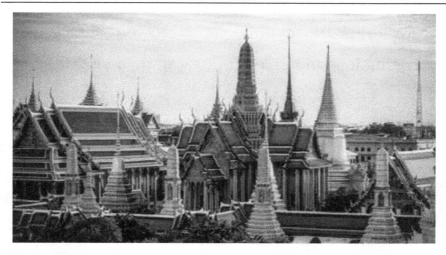

On the off chance that you like shopping you need to look at this spot. In the event that you scorn shopping you need to give this spot a wide compartment. With more than 8000 slows down covering 27 sections of land of room this is perhaps the biggest market on the planet.

Open each Saturday and Sunday it draws in almost 200,000 guests per day, you will discover all that you might envision available to be purchased here and generally at nearby costs instead of traveler costs, it is unquestionably worth getting a guide

before you go to maintain a strategic distance from you being lost on the lookout for quite a long time.

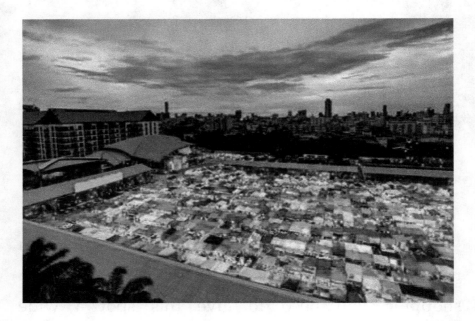

2. Pai

Pai essentially blossoms with the travel industry. Generally, it is the most attractive and amazing place to visit for tourists. Notable among explorers for its casual climate, the town is brimming with modest guesthouses, gift shops, and cafés. In the environs of the town are spas and elephant camps.

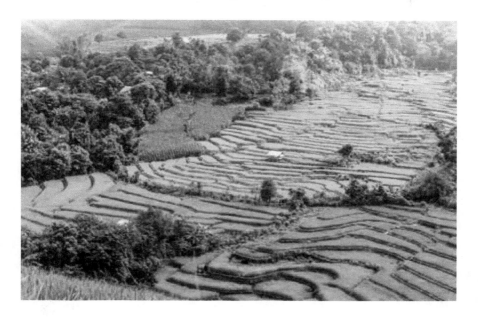

The best activities in Pai Thailand are outside of what might be expected and not your customary Thai vacation destinations. I like to consider it the 'Pai opening' in light of the fact that once you show up;

you will not have any desire to leave. I initially came to Pai for five days and wound up leaving a half year later… It resembles you're stuck on an island, simply less the sea shore and add mountains, wilderness, cascades and natural aquifers.

Pai is the sort of spot you expect to remain for a couple of evenings and wind up leaving a month later, that is its excellence. The best activities in Pai are only a short motorbike ride away, so bounce on that bicycle and investigate for yourself.

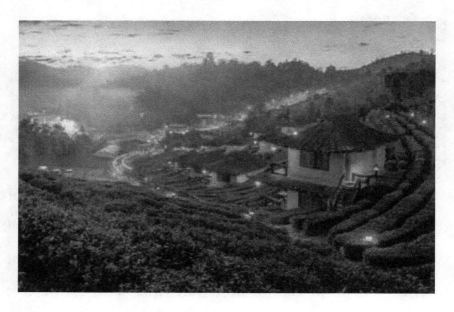

3. Khao Sok

Khao Sok is truly perhaps the most dazzling spots I've ever been on my travel. The tones, the scenes, the crudeness – it's an uncommon spot. It's home to uncommon species, for example, the goliath parasitic Rafflesia bloom, hornbill flying creatures, gibbons, and tigers. The recreation center can be enjoyed by elephant-back safari, climbing trail, and pontoon, kayak, or kayak employing the Sok stream.

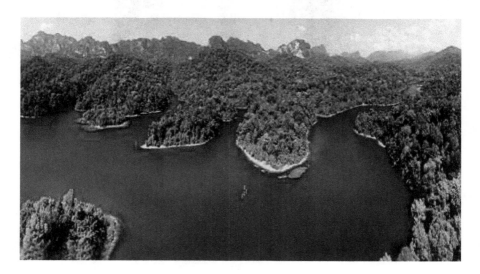

Khao Sok National Park is situated in the South of Thailand. Envision lakes, limestone mountains, rainforests (and parasites), and breathtaking perspectives. It's a well-known objective because there are numerous Khao Sok exercises each explorer ought to do while in Thailand.

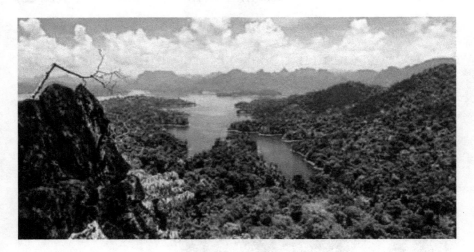

4. Sukhothai

The bubbling of culture in this city during the thirteenth and fourteenth hundreds of years CE has left a permanent engraving on Thai workmanship, language, and governmental issues, and Sukhothai is as yet venerated as the origin of Thai culture by Thais today. Further abroad in the northern zone, the overwhelming brilliant 36 foot Buddha at Wat Si Chum is well worth seeing. Access to each zone costs around 100 baht and bikes can be leased from the fundamental doors for under 50 baht each day.

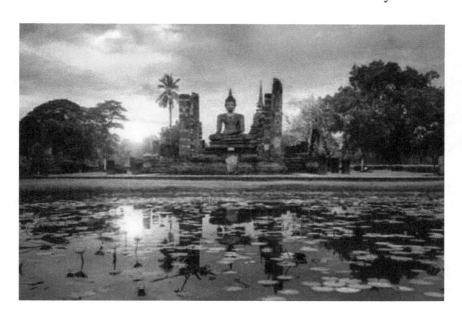

A little city in northern Thailand, Sukhothai is a well-known traveler objective because of the close by relics of an old town by a similar name. Noteworthy Sukhothai was the primary capital of Thailand, at that point, Siam, during the thirteenth century. Numerous sanctuaries, castles, and landmarks from this period can be found in the Sukhothai Historical Park.

The recreation center is partitioned into various zones, with each highlighting a few exhumed sanctuaries, chedis, Buddha figures, and different landmarks with noteworthy plaster reliefs. Wat Mahathat is viewed as the most incredible sanctuary with its standing Buddha relics and lotus-formed stupa. In the recreation center is Wat Si Chum's structure, which houses an enormous 50-foot tall sitting Buddha.

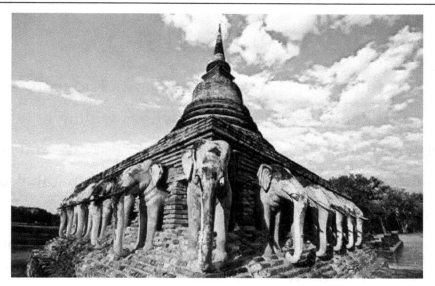

CONCLUSION

Life is full of so many opportunities and adventures, while it depends on the person who is willing to take risk and do so much in life, if you do not take stance right now how you will know the unparalleled beauty around the world, or wander what you have missed in life. Life gives do much chances and it is on us how we take them granted for ourselves.

world is full of places and sites which we cannot even imagine in life but are worth seeing and now I have given you the opportunity to see the glimpse of world here and now up to you now, how you enjoy yourselves in 2021 after so much troubles and tragedies.

CPSIA information can be obtained
at www.ICGtesting.com
Printed in the USA
BVHW050156060321
601818BV00006B/779